UXBRIDGE COLLEGE LEARNING CENTRE
Park Road, Uxbridge, Middlesex UB8 1NQ
Telephone: 01895 853326

Please return this item to the Learning Centre on
or before the last date stamped below:

HATMAKER
Visual thesaurus

741. 6

Visual Thesaurus

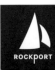

First published in the United States of America by
Rockport Publishers, Inc.
33 Commercial Street
Gloucester, Massachusetts 01930-5089
Telephone: (978) 282-9590
Fax: (978) 283-2742
www.rockpub.com

ISBN 1-56496-894-4
10 9 8 7 6 5 4 3 2

Cover Image: Goveia, Tharawanich
Design: Tharawanich, Goveia

Printed in China

Visual Thesaurus

A Quick-Flip Brainstorming Tool for Graphics Designers
Written, compiled, and designed by Hatmaker

GLOUCESTER MASSACHUSETTS

ROCKPORT PUBLISHERS

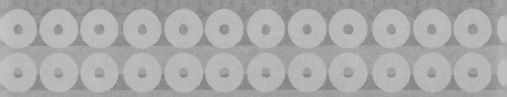

This book is dedicated to Tom Corey, founder of the Corey & Company studios: Hatmaker,

Corey McPherson Nash, BIG BLUE DOT, and Bug Island.

We think you would have liked this.

Contents

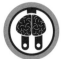

Introduction

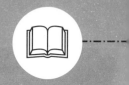

The Visual Thesaurus

A Quick-Flip Brainstorming Tool for Designers

In its most basic sense, a thesaurus is defined as a treasury. More specifically, it is a collection of synonyms for words and concepts, and often it provides opposite meanings and new directions for expansive thought. It is a tool for extending one's vocabulary. It is a tool for understanding your language.

It is a tool for overcoming writer's block.

Taking this concept and applying it to the realm of the graphic artist, we have developed the *Visual Thesaurus*—a treasury of the visual expression of common words. Some of the images shown here are literal, others are far-fetched, even whimsical. Hopefully all are provocative, inspiring visual explorations well beyond what is contained on these pages. This is not a book to be studied and digested; it is a free-for-all of imagination. It is a source of inspiration.

It is a brainstorming tool to help overcome designer's block.

Using the Thesaurus

We have explored the concrete fabrication of more than 250 words. What does courageous mean visually, as an object? What is iconic, and what ideas expand from it? Where does the word lead us?

It may be improbable to think that you will need to represent these exact words. However, they do cover a great expanse of types of words...and types of interpretation. Look up a specific word or simply flip through to set your mind free.

Going International

Below each English word are translations to other languages: Spanish, German, French, Italian, and Japanese. We acknowledge that some of the visual interpretations may not fully relate to the written translations, but we have elected not to allow this possibility to inhibit the creative process—which, after all, is the point of this book. In fact, we envy those who will need to stretch their imaginations to find a connection.

The Visual Search

In addition to the visual directions words take us, there are some practical examples of the creative process in action. We've presented the explorations and definitions that lead to the final image and composition of some very prominent logos. Logos provide us with a single point of concentration to best show development. All these logos have been highly successful; many have won design awards. More importantly for us, each shows a range of interpretation and creative opportunity in bringing meaning and life to the brand each represents.

HATMAKER

A Studio of Corey & Co.

Hatmaker is a strategy and design studio with an expertise in developing identities in the broadcast industry. From branding to show packaging to network launches and beyond, Hatmaker has built its reputation on the the intricate weave of seizing creative opportunities and consideration of client goals. We provide focused thinking on expansive possibilities. Our client list includes Cinemax, MTV, Hearst Entertainment, Warner Bros., Universal Studios, Noggin, Lifetime, ESPN, Court TV, Tech TV, and Nickelodeon.

Since 1983, Corey & Company, Inc. has grown and developed into specialized studios under one roof: Hatmaker, Corey McPherson Nash (Web, print), BIG BLUE DOT (design for kids), and Bug Island (content development). Based just outside Boston, each studio functions as its own entity, yet has the ability to form special cross-studio teams, allowing each to focus on what it does best while maintaining the talent pool and resources of a much larger firm.

CHRIS GOVEIA: AUTHOR, CREATIVE DIRECTOR

Partner and creative director of Hatmaker, Chris Goveia has been directing, designing, and producing print and broadcast design with the company for nine years. Chris takes a hands-on approach to design, spearheading extensive strategy and design projects, including the channel launches of Cosmopolitan Television and Cinemax ('98 relaunch). Chris' work continues to gain BDA awards, as well as Tellys, AIGA awards, and others. His creations, including the Cinemax logo, have been featured in books on motion graphics for both Rockport Publishers and Dimensional Illustrators. Away from the office is never a break from design, as he is usually either knocking down walls in his house, restoring antique furniture, or artfully mounting photos from his latest adventure travels.

PRANG THARAWANICH: DESIGNER

Perhaps Prang's greatest talent is her ability to balance grace, captivating beauty, and clarity of message with whimsey, urban chic, and often surreal design. Leaving her native Thailand to earn her masters degree from Savannah College of Art and Design, her experience as a designer, animator, and editor has made her a top talent. Prang's work earns a variety of design awards and is featured in several prestigious magazines. Prang's passion for creativity includes international weekend getaways and the extensive acquisition of Tim Burton films and memorabilia.

TED SMYKAL: ILLUSTRATOR, ART FINDER

A tame man with a wild imagination, Ted had a viable freelance career as an illustrator and painter before joining Hatmaker. Ted smoothly made the transition from tabletop to desktop, becoming not only a talented designer but an apprentice animator as well. His work includes designing logos, packaging, on-air elements, animation components, and backgrounds. His work on the 13th Street channel launch, interstitials for Oxygen, and the Noggin logo have garnered BDA awards. In addition, Ted is a brainstorm essential, a coveted props creator, and he helps design/develop toys, games, and software. He is also an avid collector of outrageous toys and intriguing "stuff."

ELZ BENTLEY: AUTHOR

Elz' background includes broadcast project management, writing, and voice-overs; it also includes accounting and a degree in philosophy. Her talents have blended seamlessly over the years to serve Hatmaker's clients well. When not leading naming brainstorms, writing ad copy, balancing budgets, nor thoughtfully tending the daily needs of a project, Elz can be found passing out the results of her experimental cooking or emphatically defending her latest flea market treasure as "necessary someday."

think.

words

A-Z

ABSURD

absurdo, unsinnig, absurde, assurdo, 馬鹿げた

a b c d e f g h i j k l m n o p q r s t u v w x y z

ACADEMIC

académico, akademisch, scolaire, accademico, 学究的な

AERONAUTICAL

aeronáutico, aeronautisch, aéronautique, aereonautico, 航空の

AFRAID

temeroso, befürchtend, apeuré, spaventato, 恐れて

AGGRESIVE

agresivo, aggressive, agressif, agressivo, 攻撃的な

AMERICAN

americano, amerikanisch, Américain, americano, アメリカ的な

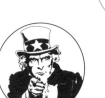

ANALYTICAL

analítico, analytisch, analytique, analitico, 分析的な

ANCIENT

antiguo, alt, ancien, antico, 古代の

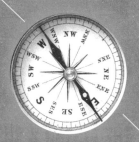

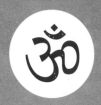

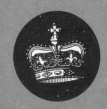

PROJECT

13TH STREET

Danger, intrigue, and suspense are the cornerstone of Universal Studios Television's international channel brand. With a name oozing infinite danger, we began explorations of what this place looked like. Fractured type, genre imagery, and locations were all explored.

Ultimately, we concentrated not on the genre specifically, but on creating a sense of place. The final logo is simple and universal—a street sign. What lurks on this street is as wide open as the viewer's imagination, as well as opening the possibilities for the look of the channel.

FINAL LOGO

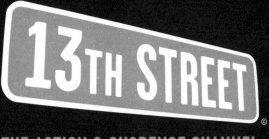

THE ACTION & SUSPENSE CHANNEL

20

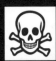

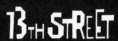

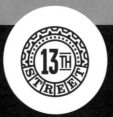

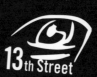

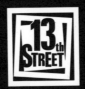

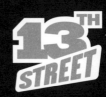

Designer: **Corey**

ANIMAL

animal, Tier, animal, animale, 動物の

ARCHAEOLOGY

arqueología, Archäologie, archéologie, archeologia, 考古学

ARTISTIC

artístico, künstlerisch, artistique, artistico, 芸術的な

ASIAN

Asiático, Asiatisch, Asiatique, asiatico, アジアの

ATHLETIC

atlético, sportlich, athlétique, atletico, 運動競技の

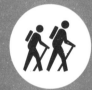

 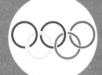

BEAUTIFUL

bello, schön, beau, bello, 美しい

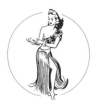
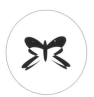

a (b) c d e f g h i j k l m n o p q r s t u v w x y z

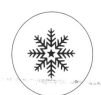
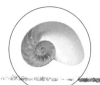

BITTER

amargo, bitter, amer, amaro, 苦い

 POISON

BLOAT

abotagarse, aufblähen, gonfler, gonfiare, 膨れる

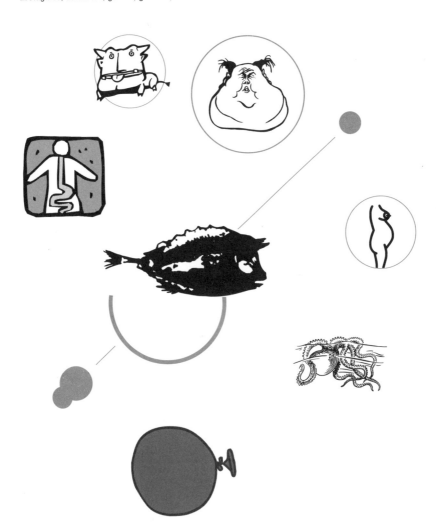

BRIGHT

brillante, hell, brillant, brillante, 明るい

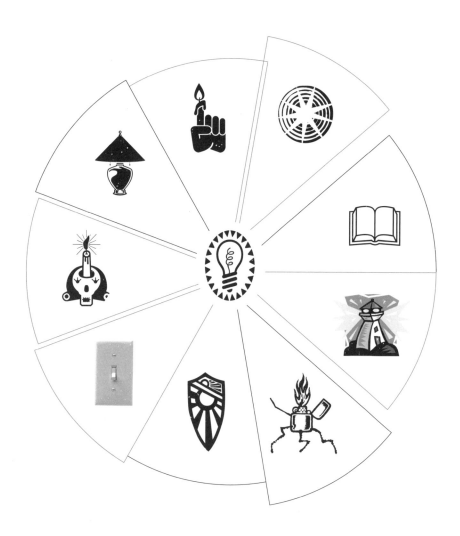

BUSTLING

animado, geschäftig, affairé, indaffarato, せわしない

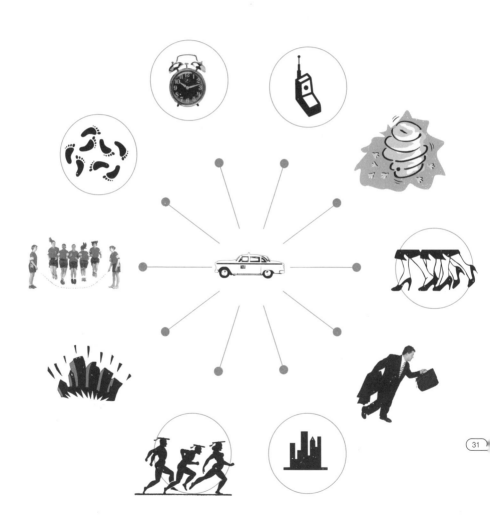

Cc

CAPABLE

capaz, fähig, capable, capace, 能力のある

CAUTIOUS

cauteloso, vorsichtig, prudent, prudente, 慎重な

a b c d e f g h i j k l m n o p q r s t u v w x y z

Cc

CELEBRATE

celebrar, feiern, célébrèr, festeggiare, 記念する

CELESTIAL

celestial, himmlisch, céleste, celestiale, 天体の

CHEAP

barato, billig, peu coûteux, economico, 安っぽい

CLASSIC

clásico, klassisch, classique, classico, クラシックな

Cc

CLEAN

limpio, sauber, propre, pulito, クリーンな

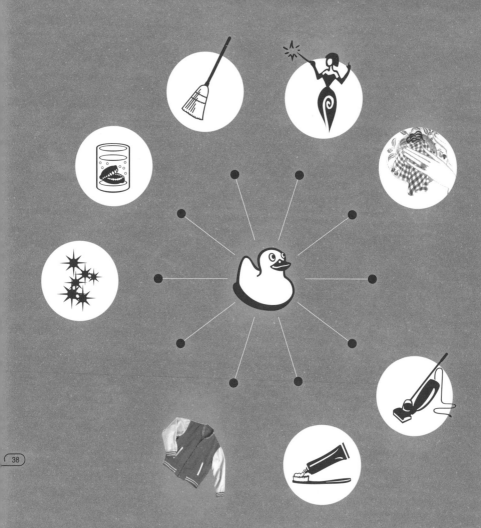

COCKTAIL

cóctel, Cocktail, cocktail, cocktail, カクテル

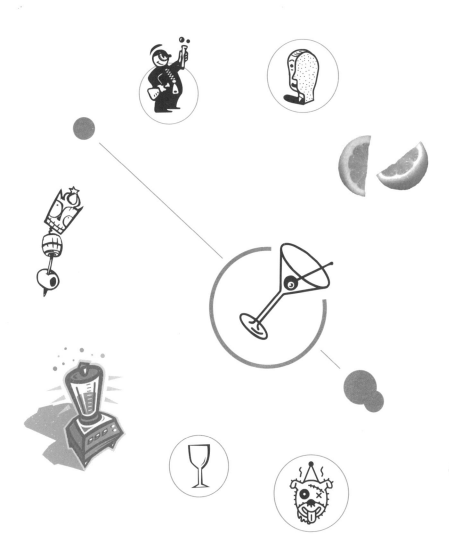

COLD

frío, kalt, froid, freddo, 冷たい

COMFORTABLE

cómodo, bequem, confortable, comodo, 心地よい

COMMUNICATION

comunicación, Kommunikation, communication, comunicazione, コミュニケーション

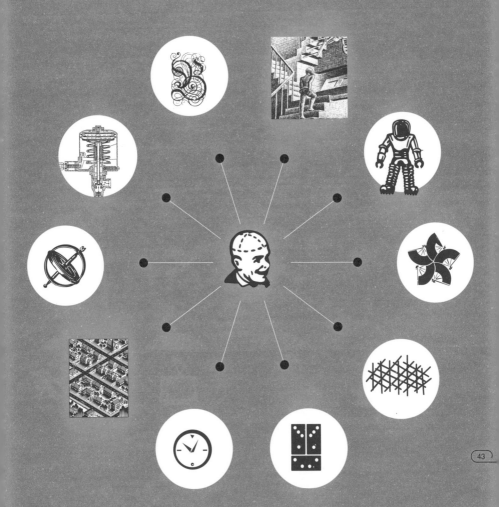

COMPLEX

complejo, complex, complexe, complesso, 複合の

OXYGEN

Oxygen addresses real lives, gives solid advice, and provides intelligent entertainment to women in a market that tends to placate or romanticize them. This fresh approach demanded a logo that thought in new directions. Abandoning generic feminine icons, we explored design that took a new look at logos themselves, then added a feminine twist. Some of these took an edgy feel, reflective of the dynamic approach of the network. Others pursued the element; still others, a non-traditional view of women.

The final logo reflects the power of suggestion—subtle strength. Parenthesis and an all-lower case type give the logo a soft, almost whispering feel, much like the element. The "o" takes on dominance as a perfect circle. In its "vapor" application, the logo is revealed by a changing background, supporting the concept of an ever-present element of life.

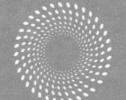

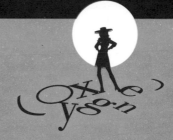

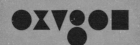

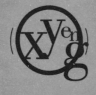

OXYGEN

/OXYGEN\

Designers: **Corey, Bedrossian**

CONSTRUCTION

construcción, Bau, construction, costruzione, 建造

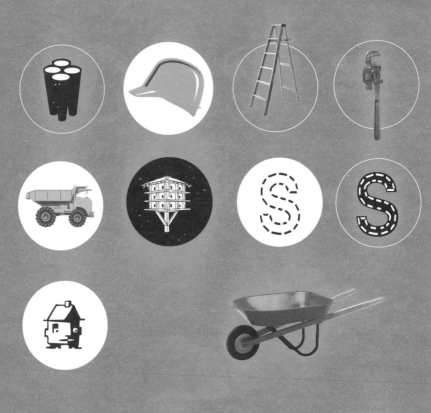

46

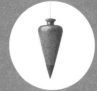

CONTAGIOUS

contagioso, ansteckend, contagieux, contagioso, 伝染性の

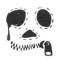
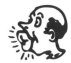

CONTEMPORARY

contemporáneo, contemporary, contemporain, contemporaneo, 現代の

CORAGEOUS

valiente, mutig, courageux, coraggioso, 勇気ある

49

CORPORATE

corporativo, Firmen-, corporatif, aziendale, 企業の

COZY

acogedor, gemütlich, douillet, accogliente, こじんまりとした

51

CREDIBLE

credible, glaubwürdig, crédible, credibile, 説得力のある

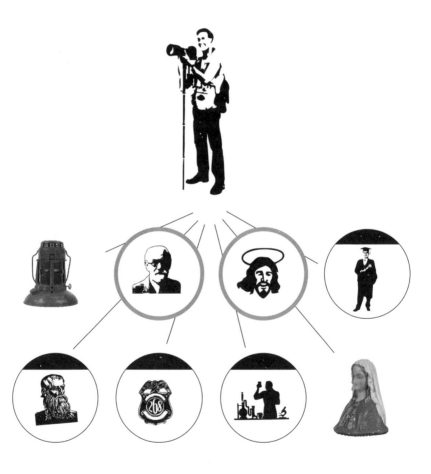

Cc

CULINARY

culinario, kulinarisch, culinaire, culinario, 料理の

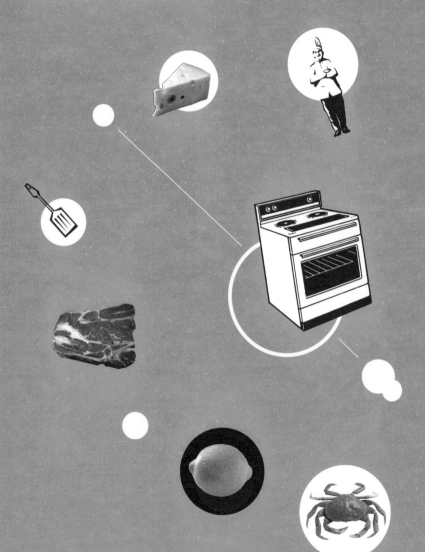

53

DANGEROUS

peligroso, gefährlich, dangereux, pericoloso, 危険な

a b c (d) e f g h i j k l m n o p q r s t u v w x y z

DARK

oscuro, dunkel, sombre, scuro, 暗い

Dd

DEAD

muerto, tot, mort, morto, 死んでいる

DEADLY

mortal, tödlich, mortel, mortale, 致命的な

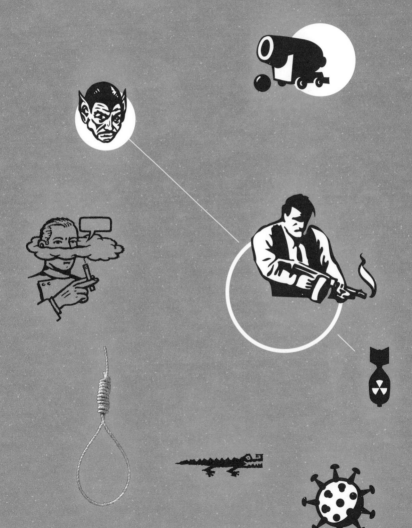

DELICIOUS

delicioso, köstlich, délicieux, squisito, おいしい

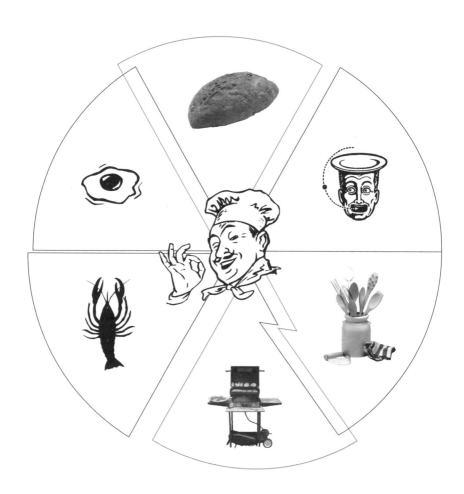

DETERMINED

decidido, entschlossen, déterminé, risoluto, 断固とした

59

DEVIANT

desviado, abweichend, déviant, tortuoso, 常軌を逸脱した

DIGNIFIED

digno, würdevoll, digne, dignitoso, 高貴な

DIRTY

sucio, schmutzig, sale, sporco, 汚い

DISHONEST

deshonesto, unehrlich, malhonnête, disonesto, 不正直な

DOMINATING

dominante, dominierend, dominateur, dominatore, 優位を占める

DRAMATIC

dramático, dramatisch, dramatique, drammatico, ドラマティック

DREAMY

maravilloso, verträumt, rêveur, sognante, 夢のような

DRUNK

borracho, betrunken, ivre, ubriaco, 酔っぱらった

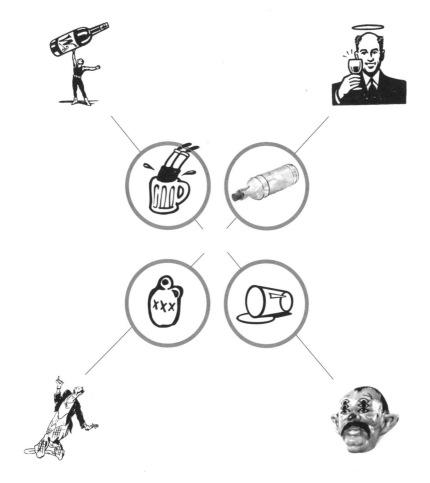

PROJECT

NICKELODEON GAS

Remember those cool games you made up as a kid? Think about what you could have come up with if you had a big budget, endless materials, and tons of people. Games, sports, and physical activity from a kid's perspective is what GAS (Games and Sports) is all about.

The suggestion of sports and games (computer, board, physical, etc.) was, of course, central to the exploration of a logo. We explored pennants, individual sports icons, kids, and much more before pursuing the textures of the various sports. Even the final logo type is reminiscent of a toy race track. Although the pronunciation is "gas," the type plays down the "a," helping it to read less like gasoline and more like G & S.

FINAL LOGO

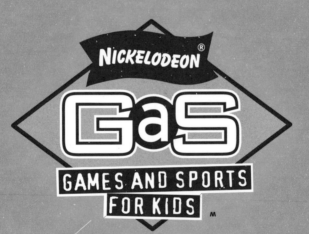

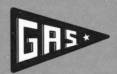

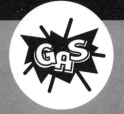

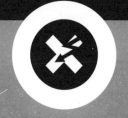

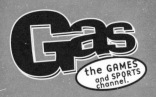

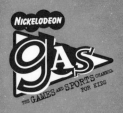

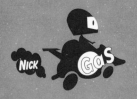

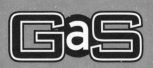

Designers: **Goveia, Nihoff**

DRY

seco, trocken, sec, secco, 乾いた

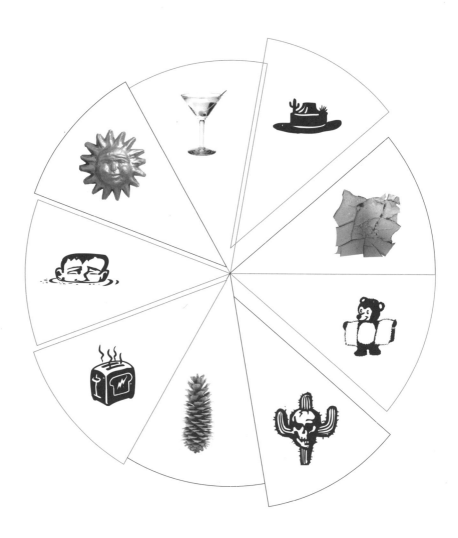

DULL

room, stumpf, ennuyeux, spuntato, 退屈な

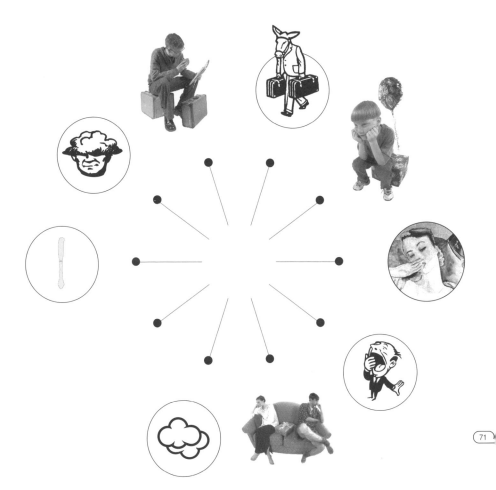

EARTHY

a tierra, erdig, terreux, terrestre, 土の、たくましい

a b c d (e) f g h i j k l m n o p q r s t u v w x y z

EASY

fácil, leicht, facile, facile, 簡単な

EGYPTIAN

egipcio, ägyptisch, Égyptien, egiziano, エジプトの

ELECTRIFYING

electrizante, elektrisierend, électrisant, elettrificante, 電化

EMBARRASSED

azorado, verlegen, embarrassé, imbarazzato, 当惑した

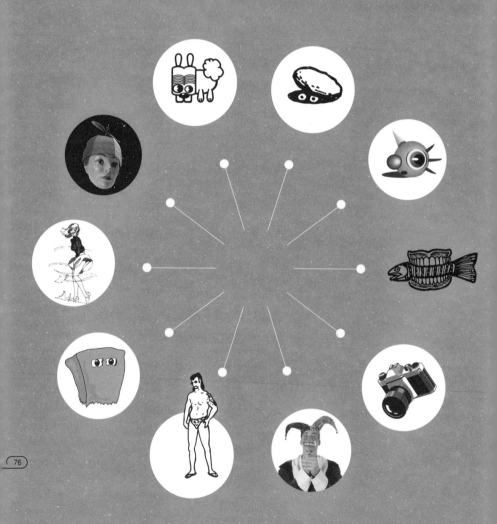

ENERGETIC

enérgico, energiegeladen, énergique, energetico, エネルギッシュな

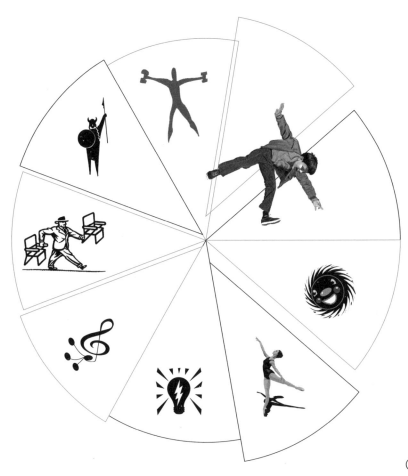

ENTERTAIN

entretener, unterhalten, amuser, intrattenere, 楽しませる

ENVIRONMENTAL

ambiental, Umwelt, écologique, ambientale, 環境の

Ee

EROTIC

erótico, erotisch, érotique, erotico, エロティックな

EXCITING

emocionante, aufregend, excitant, entusiasta, わくわくする

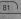

EXHAUSTED

agotado, erschöpft, épuisé, esausto, 疲弊した

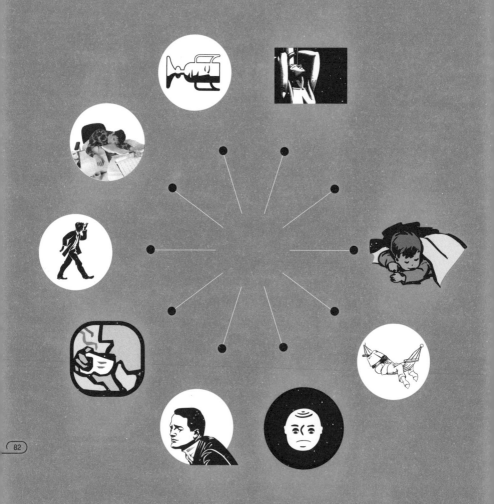

EXPENSIVE

caro, teuer, coûteux, caro, 高価な

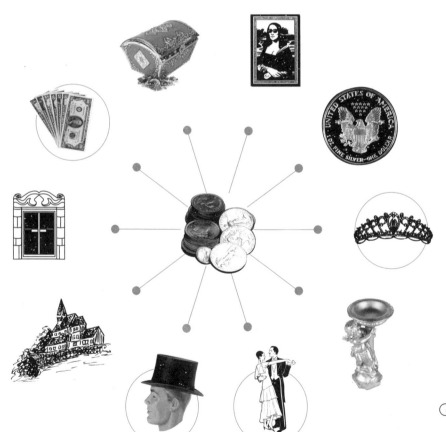

Ff

FAIRY TALE

cuento de hadas, Märchen, conte de fées, favola, おとぎ話

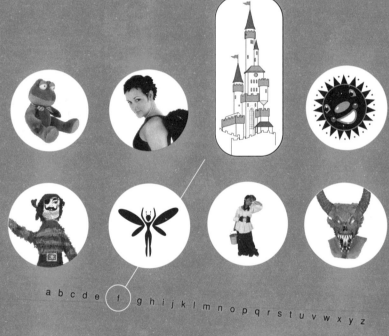

a b c d e f g h i j k l m n o p q r s t u v w x y z

FANTASY

fantasia, Fantasie, fantaisie, fantasia, ファンタジー

FAST

rápido, schnell, rapide, rapido, 速い

FAT

gordo, dick, gras, grasso, 太った

FEMININE

femenino, feminin, féminin, femminile, 女らしい

FINANCIAL

financiero, finanziell, financier, finanziario, 財政上の

FIRM

firme, fest, solide, solido, 最初の

FIRST

primero, erst, premier, primo, 堅固な

SALLY RIDE SCIENCE CLUB

Astronaut, scientist, and educator Sally Ride wanted to bring a sense of entertainment and activity to her new educational endeavor for academic, media-savvy tween girls—building on its founder's clout while inspiring a variety of sciences.

In pursuing a mark that was "cool" about science, we not only explored space but also abstract science references such as infinity, computer electronics, chemistry, mathematics, and botany. We also explored fun illustrated icons of mechanical marvels in varying degrees of reality. The final logo is both fun and surprisingly adult.

FINAL LOGO

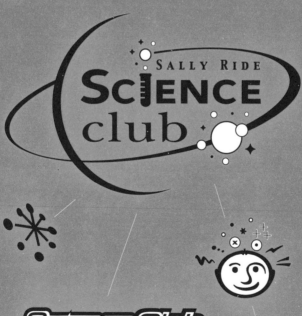

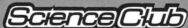

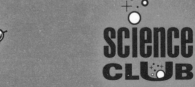

SCIENCE CLUB

Designers: **Tharawanich, Goveia, Smykal, Fisher**

FLEXIBLE

flexible, biegsam, flexible, flessibile, 柔軟な

FOCUSED

enfocado, scharf, concentré, concentrato, 焦点を合わせた

FRAGILE

frágil, zerbrechlich, fragile, fragile, 華奢な

FRENCH

francés, französisch, Français, francese, フランスの

FRESH

fresco, frisch, frais, fresco, 新鮮な

FRIENDLY

amigable, freundlich, amical, amichevole, 友好的な

FRUITY

afrutado, fruchtig, fruité, fruttato, フルーティな

FUN

divertido, Spaß machen, plaisir, divertimento, 戯れ

Ff

FUNNY

gracioso, komisch, amusant, divertente, おかしい

FUTURISTIC

futurista, futuristisch, futuriste, futuristico, 未来的な

Gg

GAME

juego, Spiel, jeu, gioco, ゲーム

abcdef **g** hijklmnopqrstuvwxyz

Gg

GEOGRAPHY

geografía, Geografie, géographie, geografia, 地理学

105

Gg

GEOMETRIC

geométrico, geometrisch, géométrique, geometrico, 幾何学

GERMAN

alemán, deutsch, Allemand, tedesco, ドイツ

GLOWING

encendido, glühend, incandescent, splendente, 燃えるような

GOVERNMENT

gobierno, Regierung, gouvernement, stato, 政治

GRACEFUL

elegante, anmutig, gracieux, grazioso, 優美な

GRAND

magnífico, grandiose, grand, imponente, 雄大な

GREEDY

avaricioso, gierig, avide, avido, 欲張りな

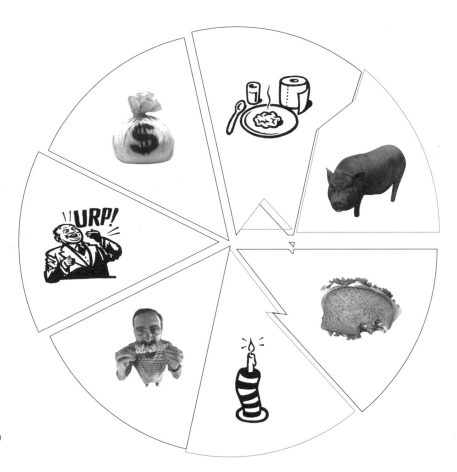

GROUCHY

gruñón, griesgrämig, grincheux, brontolone, 不機嫌な

GROWING

creciente, wachsend, croissant, crescente, 発育盛りの

GUIDANCE

orientación, Beratung, conseils, guida, ガイダンス

NOGGIN

Edu-tainment found its high-standard mark when Nickelodeon and The Children's Television Workshop teamed up to launch Noggin. The digital channel does more than teach and entertain kids—Noggin sparks kids' excitement and desire for learning. Its logo supports this notion of expansive possibilities. The generic face and mask-like type give the logo an everyman quality while allowing for the "brain" to change, reflecting the variety of knowledge available.

As with any morphing logo, there are a few hard and fast rules for use. The mouth has a limited library of provided expressions, the type is constant except that it may wink its eye, and the brain must at least loosely complete the shape of the head. Rules for color use help keep Noggin fresh yet consistent.

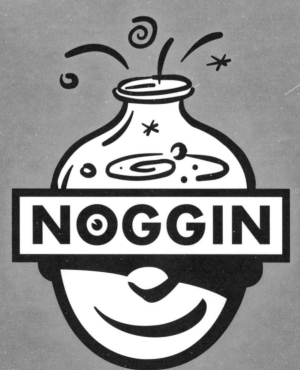

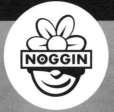
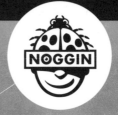
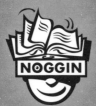
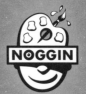
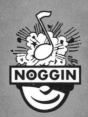
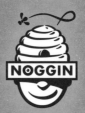
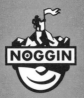
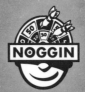
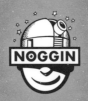

Designers: **Corey, O'Mecko, Fisher, Smykal**

Hh

HAND-CRAFTED

artesanal, handgearbeitet, fait à la main, fatto a mano, 手工芸の

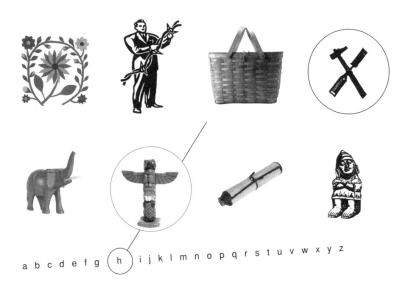

a b c d e f g (h) i j k l m n o p q r s t u v w x y z

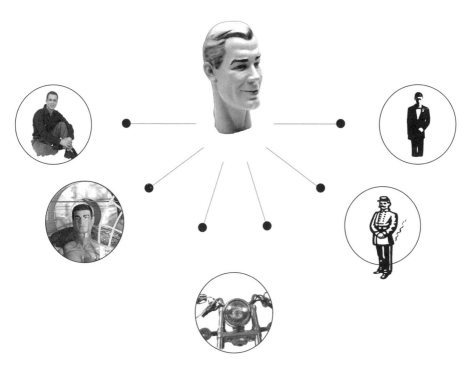

HANDSOME

guapo, gut aussehend, beau, attraente, ハンサムな

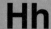

HAPPY

feliz, glücklich, heureux, felice, 幸福な

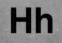

HEALTHY

sano, gesund, sain, sano, 健康的な

HEARTY

sustancioso, herzlich, vigoureux, abbondante, 心からの

HEAVENLY

celestial, himmlisch, divin, celestiale, 天国の

HELPFUL

útil, hilfreich, utile, utile, 助けになる

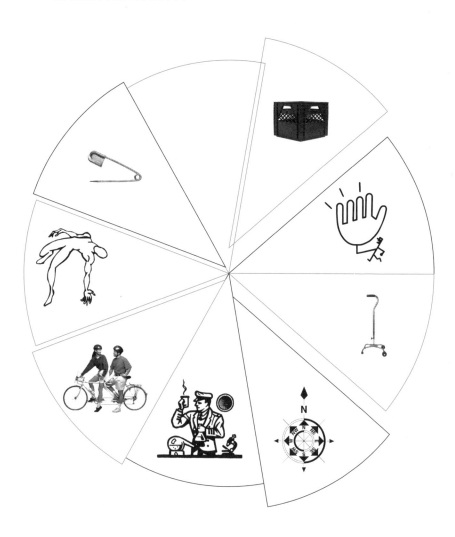

HIGH-TECH

de alta tecnología, hitech, high-tech, alta tecnologia, ハイテク

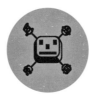

www

HOLIDAY

día feriado, Feiertag, congé, festa, 休日

HONEST

honrado, ehrlich, honnête, onesto, 正直な

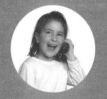

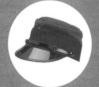

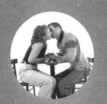

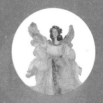

HONORABLE

honorable, ehrenhafts, honorable, onorabile, 名誉ある

HOPELESS

desesperado, hoffnungslos, désespéré, disperato, 絶望的な

HOSPITABLE

hospitalario, gastfreundlich, hospitalier, ospitale, もてなしのよい

HOT

caliente, heiß, chaud, caldo, 暑い、熱い

HUGE

enorme, riesig, énorme, enorme, 巨大な

HUMAN

humano, menschlich, humain, umano, 人間の

ILLNESS

enfermedad, Krankheit, maladie, malattia, 病気

a b c d e f g h i j k l m n o p q r s t u v w x y z

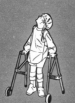

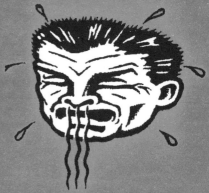

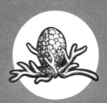

IMMEDIATE

inmediato, sofortig, immédiat, immediato, すぐに

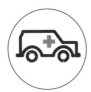

IMPORTANT

importante, wichtig, important, importante, 重要な

INDUSTRIOUS

diligente, arbeitsam, travailleur, diligente, 勤勉な

INSANE

loco, geisteskrank, fou, pazzo, 狂気の

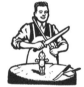
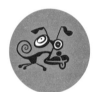
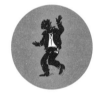

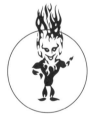

ITALIAN

italiano, italienisch, Italien, italiano, イタリアの

ACTION MAX

In creating the Cinemax logo and isolating "Max," we opened the door to branded, genre-focused subchannels. We established a dynamic font for use on all of the channels and created iconic accents to reinforce the genre. By leaving the Max dot untouched and keeping the imagery to a minimum, there is an automatic connection to the parent network. The composition of color follows a pattern while individual colors vary for each network.

Presently, the Cinemax family of digital channels has seven separate entities, each based on the concept shown here.

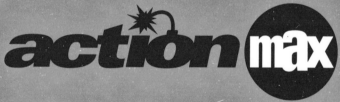

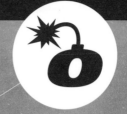

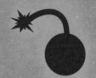

Designers: **Goveia, Luzier, Duffy**

JAPANESE

japonés, japanisch, Japonais, giapponese, うらやましい

a b c d e f g h i (j) k l m n o p q r s t u v w x y z

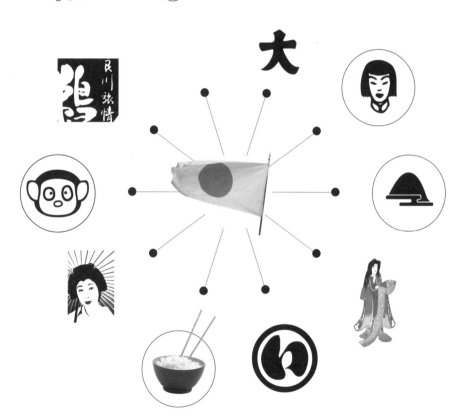

JEALOUS

celoso, eifersüchtig, jaloux, geloso, 日本の

JUSTICE

justicia, Gerechtigkeit, justice, giustizia, 正義

JUVENILE

juvenil, kindisch, juvénile, infantile, 少年少女向きの

LAME

cojo, lahm, boiteux, storpio, 不自由な

a b c d e f g h i j k l m n o p q r s t u v w x y z

LANDMARK

monumento, Wahrzeichen, point de repère, punto dt riferimento, 目印

LARGE

grande, groß, large, grande, 大きい

LATIN

latino, lateinisch, Latin, latino, ラテンの

LAZY

vago, faul, paresseux, pigro, 怠け者の

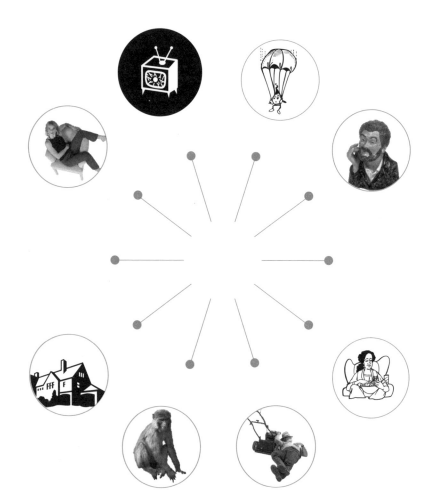

LIGHT

ligero, hell, léger, chiaro, 軽い

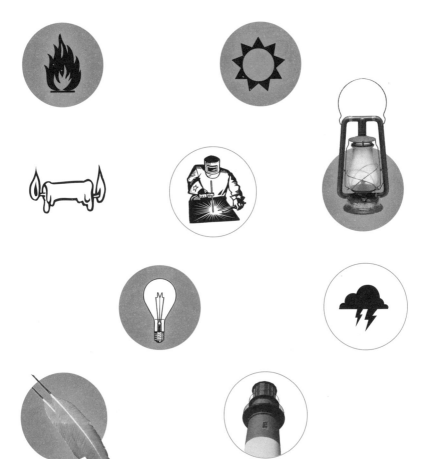

LOGICAL

lógico, logisch, logique, logico, 論理的な

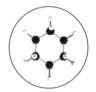

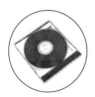

LONG

largo, lang, long, lungo, 長い

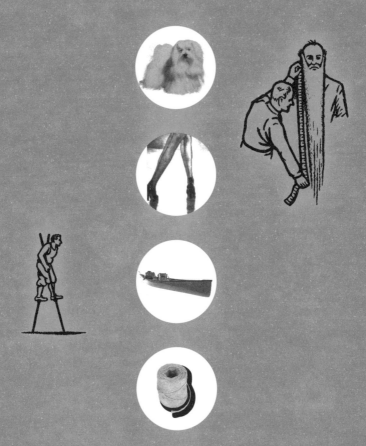

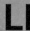

LOVABLE

adorable, liebenswert, adorable, amabile, 愛すべき

LUCKY

afortunado, glücklich, chanceux, fortunato, 幸運な

MACHINERY

maquinaria, Maschinerie, machinerie, macchinario, 機械

MAGICAL

mágico, magisch, magique, magico, 魔法の

MASCULINE

masculine, männlich, masculin, maschile, 男性の

MATURE

maduro, reif, mature, maturo, 円熟した

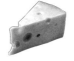

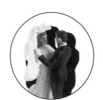

MATRIMONY

matrimonio, Ehe, mariage, matrimonio, 婚姻

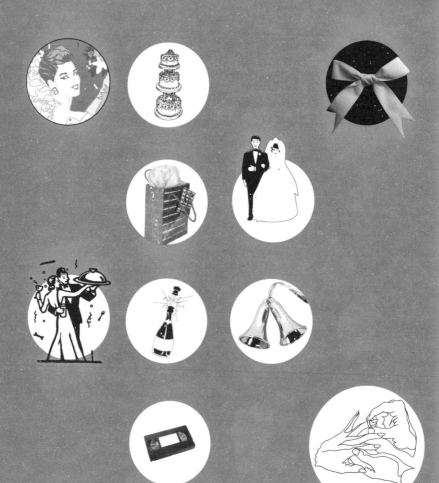

MEDIA

medios, Medien, média, media, 媒体

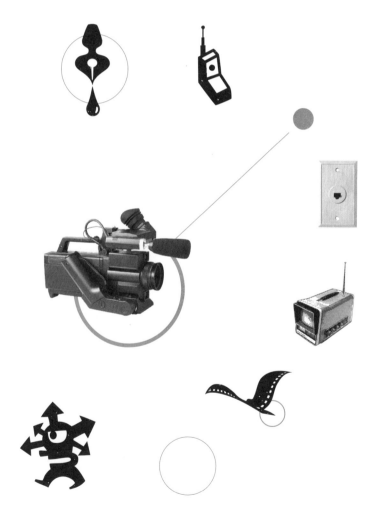

PROJECT

FROM THE TOP

From the Top, public radio's popular weekly program, celebrates young people with a passion for classical music. In addition to hearing young performers, the show's host also chats with them, making it much more of a musical variety event. The overall look and feel of the logo wanted to be bold and celebratory—youthful without being childish. The show was originally a competition, which greatly influenced the logo development. The radio contest concept seemed to harken the golden era of radio, and the imagery explored reflected this. The logo design was also intended as a physical medallion to be awarded, which not only inspired the shape but the sense of radiance around the microphone.

FINAL LOGO

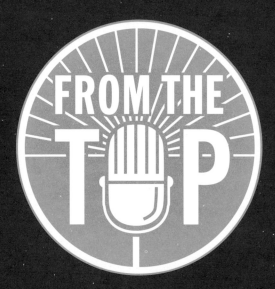

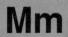

MEDICAL

medico, medizinisch, médical, medico, 医学の

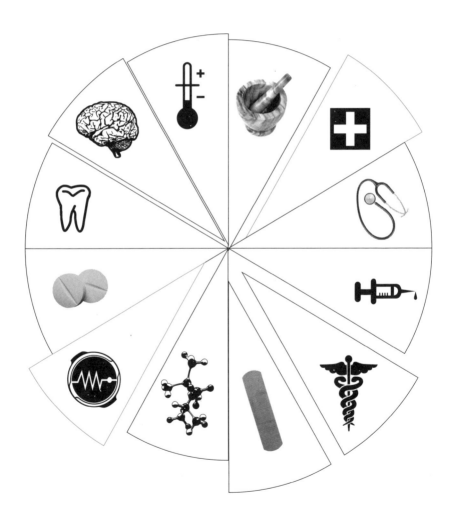

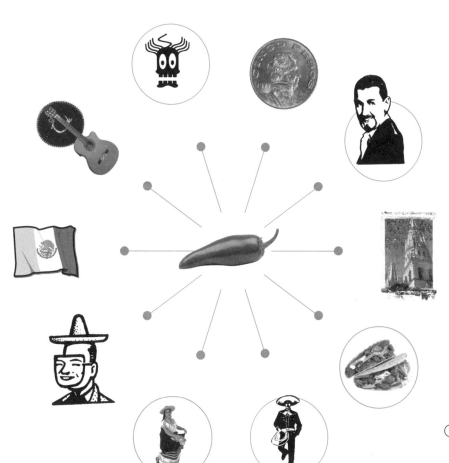

MEXICAN

mexicano, mexikanisch, Mexicain, messicano, メキシコの

MILITARY

military, militärisch, militaire, militare, 軍用

MODERN

moderno, modern, moderne, moderno, 現代の

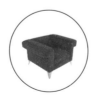

MUSICAL

musical, musikalisch, musical, musicale, 音楽の

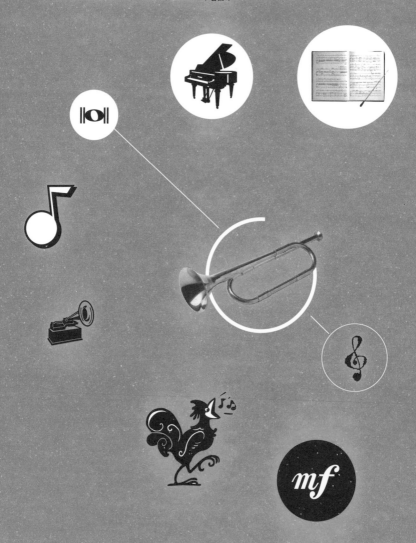

MYSTERIOUS

misterioso, mysteriös, mystérieux, misterioso, 神秘的な

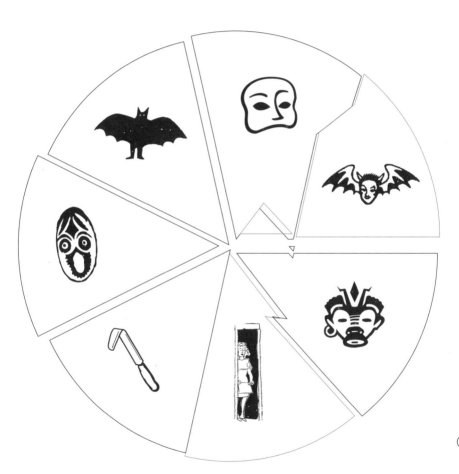

NATURAL

natural, natürlich, naturel, naturale, 自然の

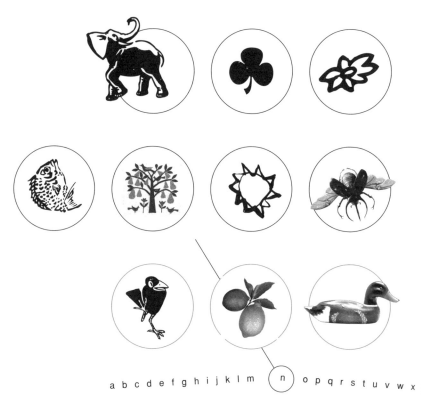

a b c d e f g h i j k l m n o p q r s t u v w x y z

NAUTICAL

naútico, nautisch, nautique, nautico, 航海の

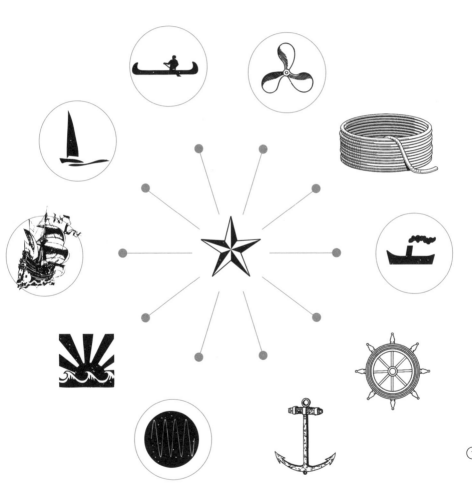

NERDY

no sofisticado, schwachköpfig, abruti, secchione, 無能な

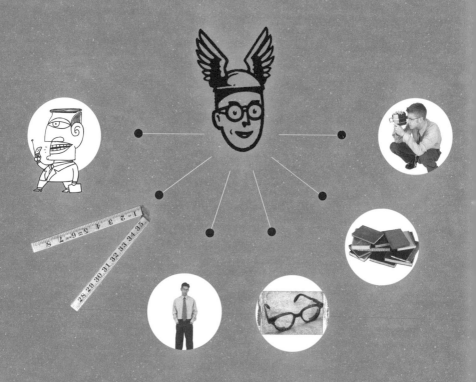

NERVOUS

nervioso, nervös, nerveux, nervoso, 神経質な

NEW

Nuevo, Neu, nouveau, nuovo, 新しい

NOISY

ruidoso, laut, bruyant, rumoroso, 騒がしい

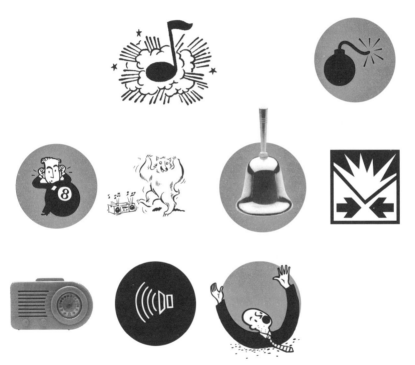

OBSOLETE

obsoleto, veraltet, désuet, obsoleto, 廃れた

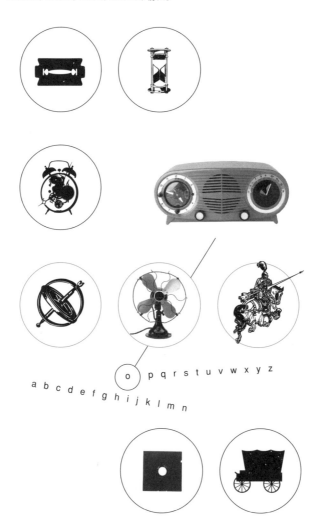

a b c d e f g h i j k l m n o p q r s t u v w x y z

OBEDIENT

obediente, gehorsam, obéissant, obbediente, 従順な

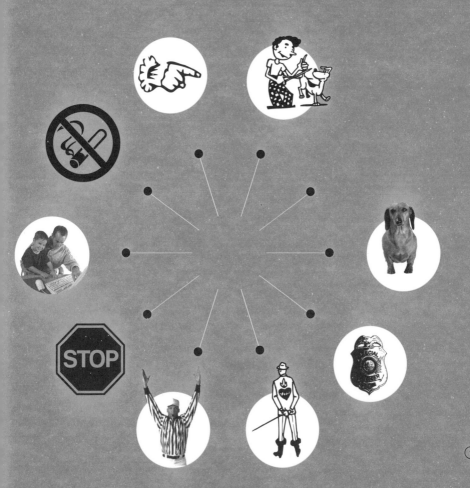

Oo

OBLIVIOUS

ajeno, ahnungslos, inconscient, distratto, 没頭して

OBSCURE

oscuro, obskur, obscur, oscuro, はっきりしない

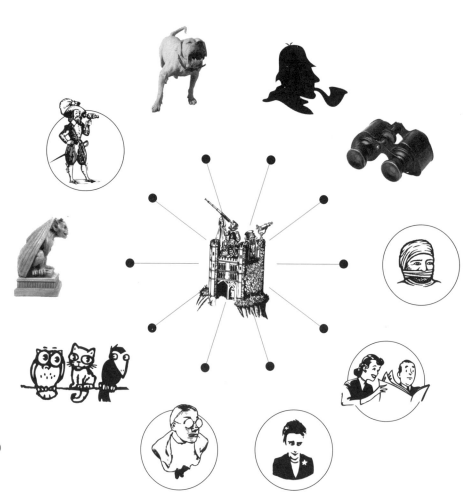

OBSERVANT

observador, aufmerksam, observateur, perspicace, 観察力の鋭い

OCCULT

oculto, geheimnisvoll, occulte, occulto, オカルト

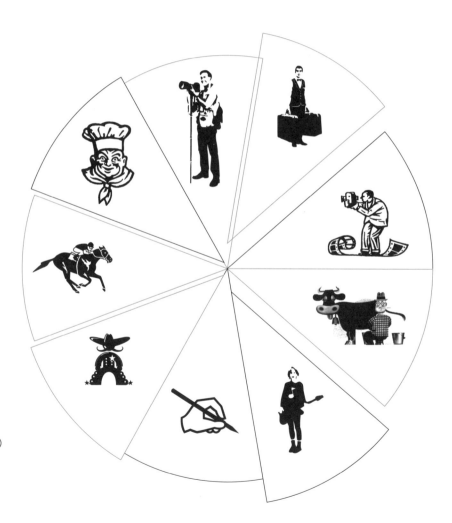

OCCUPATION

ocupación, Beruf, profession, occupazione, 職業

OCEANIC

oceánico, Meeres, océanique, oceanico, 大洋の

ODD

raro, merkwürdig, étrange, strano, 風変わりな

ODOROUS

oloroso, wohlriechend, odorant, odoroso, 匂いのする

PROJECT

TOTALLY BROADWAY TV

Totally Broadway is the interactive television emergence of the popular broadway.com Web site. For this new entity, Hatmaker focused on the icons of Broadway—the star, the marquee, and the glittering lights. The logo itself is reminiscent of the classic Broadway marquee, with its suggested perspective and larger-than-life lettering. The "lights of Broadway" are literally captured in Totally Broadway's logo animation.

FINAL LOGO

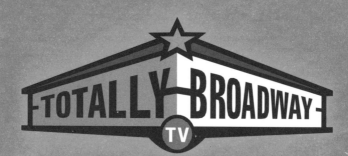

Broadway
TiCKET TV

Broadway
SCENE TV

BROADWAY
TiCKET
TELEVISION

BROADWAY SCENE

Designers: **Tharawanich, Goveia, Smykal**

OFFBEAT

poco convencional, unkonventionell, excentrique, anticonformistico, 突飛な

OFFENSIVE

ofensivo, anstößig, offensant, offensivo, 不快な

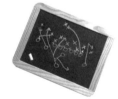

OFFICIAL

official, offiziell, officiel, ufficiale, 正式な

OLD

viejo, alt, vieux, vecchio, 古い

OLD-FASHIONED

anticuado, altmodisch, vieillot, antiquato, 時代遅れの

OPEN-MINDED

de actitud abierta, aufgeschlossen, à l'esprit ouvert, illuminato, 偏見のない

OPPOSITE

opuesto, entgegengesetzt, contraire, opposto, 対向する

OPPRESSIVE

opresivo, drückend, oppressant, oppressivo, 過酷な

Oo

OPTIMISTIC

optimista, optimistisch, optimiste, ottimista, 楽観的な

OPULENT

opulento, üppig, opulent, opulento, 富裕な

ORGANIC

orgánico, organisch, organique, organico, 組織的な

ORGANIZED

organizado, organisiert, organisé, organizzato, 有機的な

ORTHODOX

ortodoxo, orthodox, orthodoxe, ortodosso, オーソドックスな

OUTLANDISH

extravagante, absonderlich, exotique, straniero, 無法者

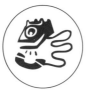

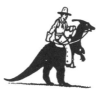
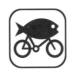

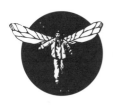

OUTLAW

bandido, Geächtete, hors-la-loi, bandito, 奇異な

OUTSPOKEN

directo, freimütig, franc, esplicito, 率直な

PAINFUL

doloroso, schmerzhaft, douloureux, doloroso, 苦痛な

a b c d e f g h i j k l m n o p q r s t u v w x y z

PARTNER

compañero, Partner, partenaire, compagno, パートナー

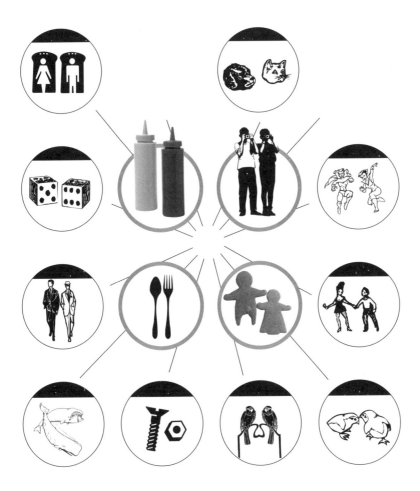

PEACEFUL

pacífico, friedlich, paisible, pacifico, 平和的な

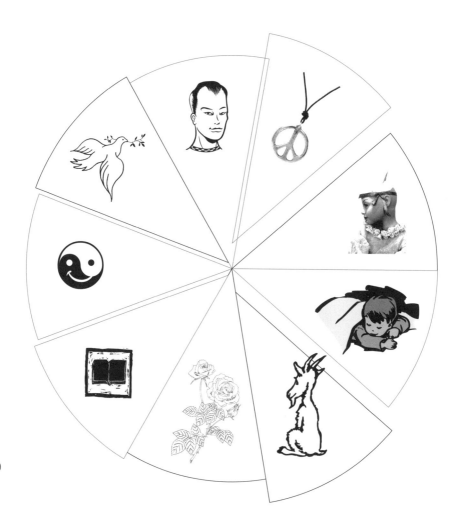

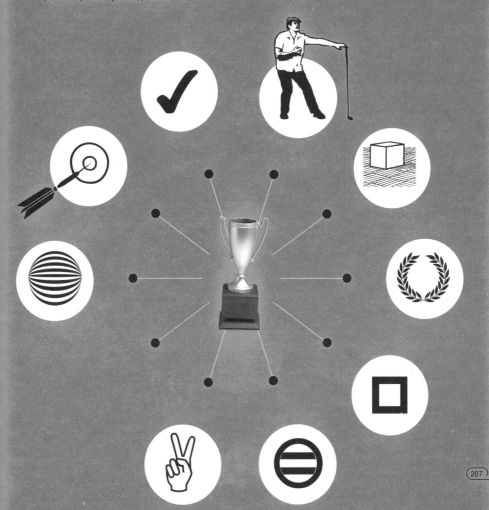

PERFECT

perfecto, perfekt, parfait, perfetto, 完全な

PERSPECTIVE

perspectiva, Perspektive, perspective, prospettiva, 考え方

PLAYFUL

juguetón, neckisch, espiègle, scherzoso, おどけた

PROJECT

NICKELODEON

When Nickelodeon first launched, it took an almost archaic name into modern, kid-savvy times. The network wanted to appeal to today's and tomorrow's kids in a flavor that could expand with their changing world. Rather than seeking to visually convey the word itself, we stripped it of any meaning—creating two-dimensional modeling clay of tangerine with billowing white type. The result left Nickelodeon free to define itself.

To establish it as a logo, there had to be rules: the orange may have fly-away extremities but is otherwise a solid mass of flat PMS color. The type does not change (aside from a provided skew version) and is the only thing contained in the shape. And, of course, the shape must resonate fun and kid-appeal.

FINAL LOGO

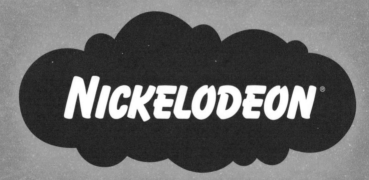

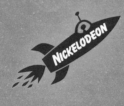

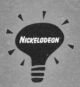

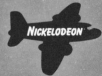

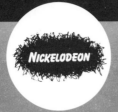

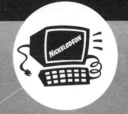

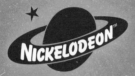

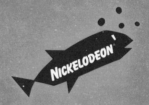

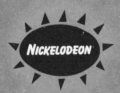

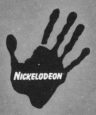

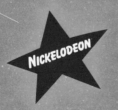

Designer: **Corey**

POOR

pobre, arm, pauvre, povero, 貧しい

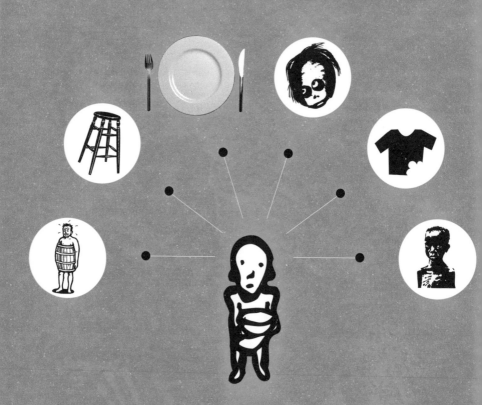

POWERFUL

poderoso, mächtig, puissant, potente, 力強い

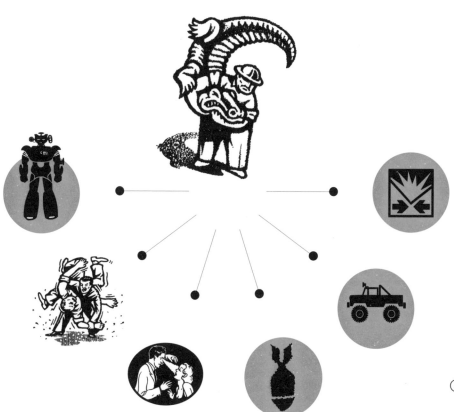

PRAISE

elogios, Lob, éloge, lode, 賞賛する

PREHISTORIC

prehistórico, prähistorisch, préhistorique, preistorico, 有史以前の

PROFESSIONAL

professional, beruflich, professionnel, professionale, 職業上の

PROMOTIONAL

promocional, Werbe-, publicitaire, promozionale, 販売を促進する

PROTECTIVE

protector, beschützend, protecteur, protettivo, 保護的な

PROUD

orgulloso, stolz, fier, orgoglioso, 自慢の

QUAINT

extraño, urig, bizarre, pittoresco, 古風で趣がある

q r s t u v w x y z

a b c d e f g h i j k l m n o p

QUIET

callado, ruhig, tranquille, tranquillo, 静かな

Rr

RECREATIONAL

recreativo, erholsam, récréatif, ricreativo, リクリエーションの

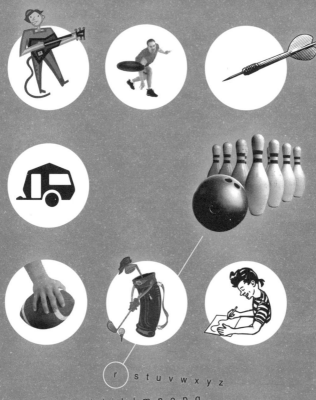

r s t u v w x y z

a b c d e f g h i j k l m n o p q

REFLECTIVE

reflectante, reflektierend, réfléchi, riflessivo, 反射する

Rr

REFRESHING

refrescante, erfrischend, rafraîchissant, rinfrescante, 新鮮な

REJOICE

alegrarse mucho, erfreuen, réjouir, godere, 祝賀する

REJUVENATING

rejuvenecedor, verjüngende, rajeunissant, ringiovanente, 若返らせる

RELAXING

relajante, entspannend, relaxant, rilassante, リラックスした

RELIABLE

confiable, zuverlässig, fiable, affidevole, 信頼のおける

RELIEF

alivio, Erleichterung, soulagement, sollievo, 軽減

RETRO

retro, Retro-, rétro, nostalgico, レトロな

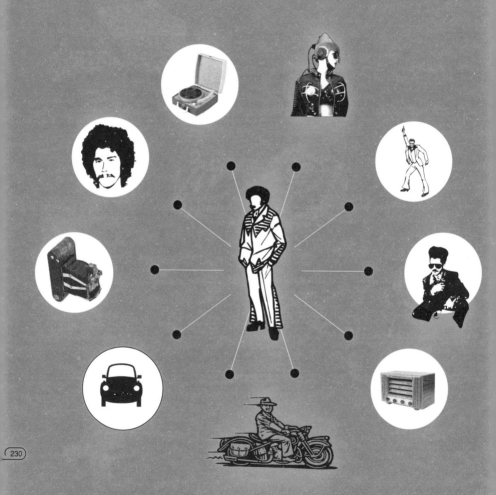

RICH

rico, reich, riche, ricco, 豊かな

ROMANTIC

romántico, romantisch, romantique, romantico, ロマンティックな

ROUGH

áspero, uneben, rugueux, aspro, 荒い

ROYAL

real, königlich, royal, reale, 王室の

RURAL

rural, ländlich, rural, rurale, 田園風の

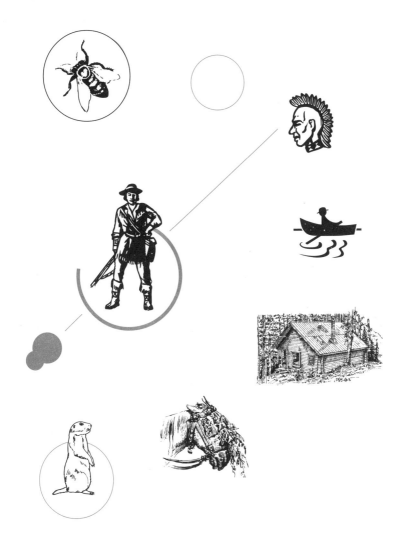

TOTALLY HOLLYWOOD TV

Hollywood Media Corp has brought its highly successful Web site, hollywood.com, into the realm of interactive television, and with the new venture came a new name: Totally Hollywood. To help lend a sense of relationship to its sister channel, Totally Broadway, and yet allow it as a stand-alone entity, Hatmaker used the dual significance of the star, then built upon it to create a panoramic big-screen feel for Totally Hollywood.

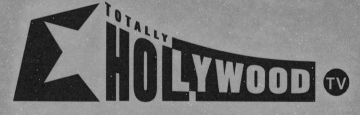

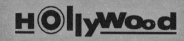

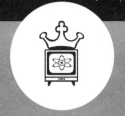

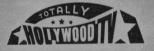

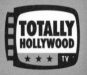

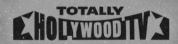

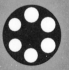

Designers: **Tharawanich, Smykal**

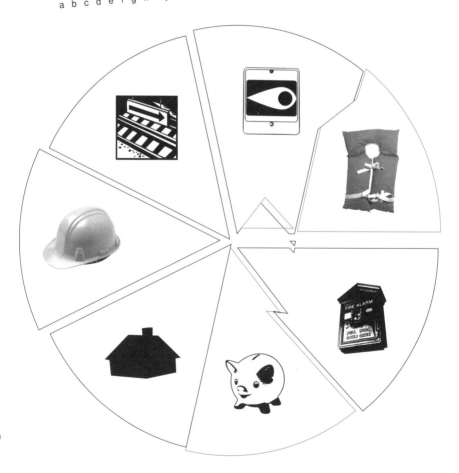

Ss

SAFE

seguro, sicher, sûr, sicuro, 安全な

a b c d e f g h i j k l m n o p q r (s) t u v w x y z

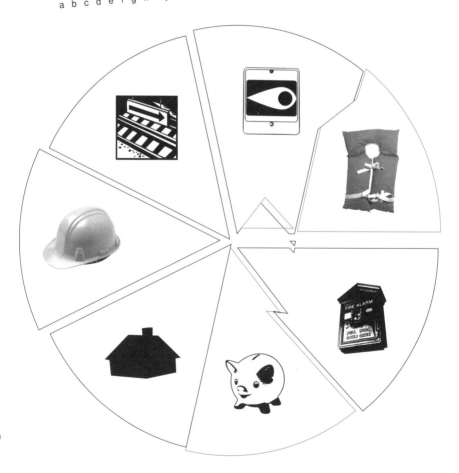

SCARY

de terror, unheimlich, effrayant, spaventoso, 恐ろしい

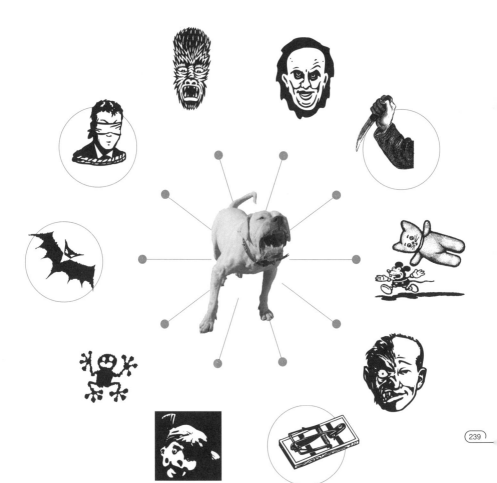

SCATTERED

disperso, verstreut, dispersé, sparso, 散在する

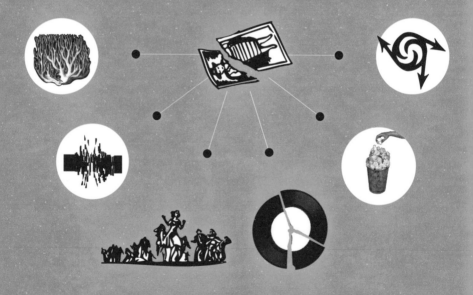

SCIENTIFIC

científico, wissenschaftlich, scientifique, scientifico, 科学的な

SECRETIVE

reservado, geheimnisvoll, secret, segreto, 秘密の

SENSUAL

sensual, sinnlich, sensuel, sensuale, 官能的な

SEXUAL

sexual, sexuell, sexuel, sessuale, セクシーな

SHARING

compartiendo, teilen, partageant, condividendo, 分担

SILLY

tonto, albern, idiot, sciocco, 馬鹿げた

SIMPLE

sencillo, einfach, simple, semplice, シンプルな

SINGLE

solo, einzig, seul, singolo, 唯一の

SKILLFUL

hábil, geschickt, habile, abile, 熟練した

SKINNY

flaco, dünn, maigrelet, magro, やせこけた

SLEEK

lustrose, geschmeidig, soigné, lisciato, なめらかな

SLEEPY

somnoliento, müde, endormi, assonnato, 眠た気な

SLICK

hábil, gewieft, enjôleur, untuoso, すべすべした

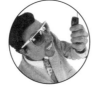

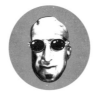

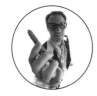

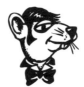

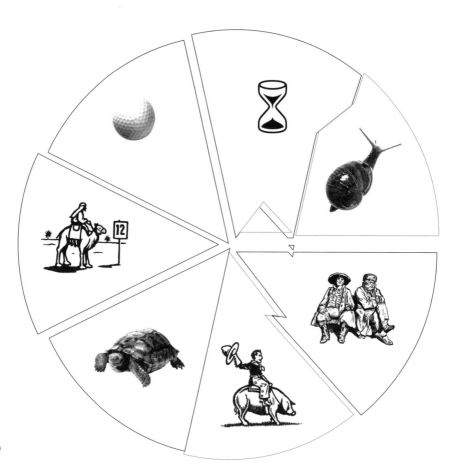

Ss

SLOW

lento, langsam, lent, lento, 遅い

SMALL

pequeño, klein, petit, piccolo, 小さい

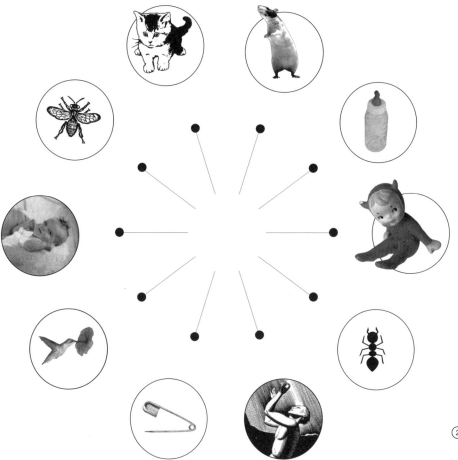

SMART

inteligente, schlau, malin, intelligente, スマートな

SMOOTH

liso, glatt, lisse, liscio, 円滑な

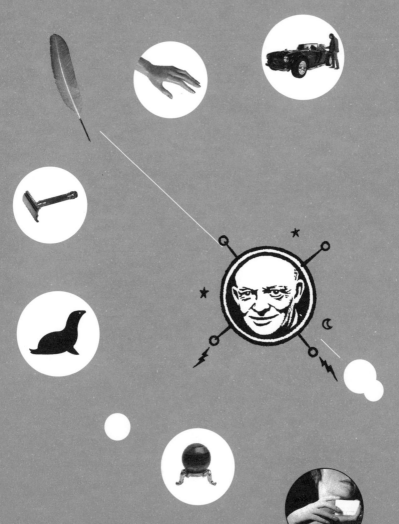

PROJECT

CINEMAX

As Cinemax increasingly referred to itself by its more dynamic and popular nickname, Max, it became beneficial to pursue a logo which would allow for this duality. Toward this, we explored a means of visually separating Max from the rest of the name. Ultimately avoiding cliché movie imagery which would dilute the impact, we concentrated on type and shapes which would maintain instant recognition whether seen as Cinemax or Max.

FINAL LOGO

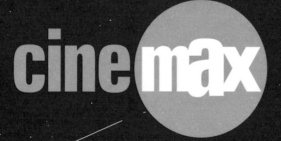

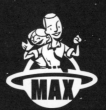

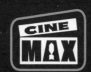

Designers: **Goveia, Schroder**

SOCIAL

social, gesellschaftlisch, social, sociale, 社会の

SOFT

blando, wiech, doux, morbido, 柔らかい

SOPHISTICATED

sofisticado, kultiviert, sophistiqué, sofisticato, 洗練された

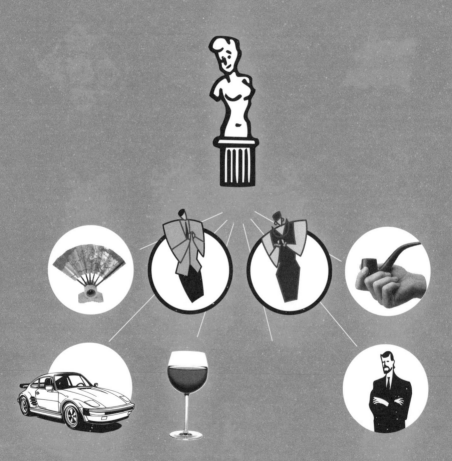

SPANISH

español, spanisch, Espagnol, spagnolo, スペインの

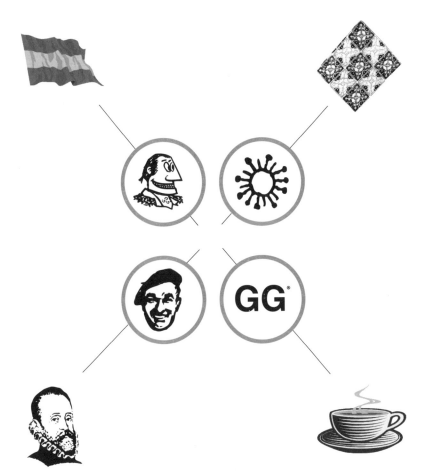

Ss

SPY

espía, Spion, espion, spia, スパイ

STICKY

pegajoso, klebrigs, poisseux, viscoso, ねばねばした

STIFF

tieso, steif, rigide, rigido, こわばった

STREAMLINED

aerodinámico, stromlinienförmig, simplifié, semplificato, 流線形の

STRONG

fuerte, stark, fort, forte, 強い

STUBBORN

terco, stur, têtu, cocciuto, 頑固な

STUPID

estúpido, dumm, stupide, stupido, 馬鹿な

STYLISH

elegante, elegant, chic, elegante, スタイリッシュな

Tt

TEAMWORK

trabajo en equipo, Gemeinschaftsarbeit, travail d'équipe, collaborazione, チームワーク

t u v w x y z

a b c d e f g h i j k l m n o p q r s

TENDER

tierno, liebevoll, tendre, tenero, 優しい

THANKFUL

agradecido, dankbar, reconnaissant, riconoscente, ありがたい

THRIFTY

ahorrativo, sparsam, économe, frugale, つましい

TIMELY

oportuno, rechtzeitig, opportun, tempestivo, 時を得た

TRAGIC

trágico, tragisch, tragique, tragico, 悲劇の

TRAVEL

viajes, Reisen, voyage, viaggio, 旅行

TROPICAL

tropical, tropisch, tropique, tropicale, 熱帯の

279

HATMAKER

A strategic design firm must wear many hats to fully serve its clients. It is on this premise that Hatmaker's name and its morphing logo take their cue. With the logo, we created a circular mark, defined by the spaced, arching type over a variety of heads. In this respect, our company name is the only "hat" ever used in our promotion.

The illustrated library of intriguing and distinctive heads is more than just a matter of whimsey; it is analogous to our flexibility and to the distinctive identities we create for our clients. To date, the library of Hatmaker logos reaches over 100, although not all are used externally.

Designers: **Corey, Fisher, Smykal**

UGLY

feo, hässlich, laid, brutto, 醜い

t u v w x y z
a b c d e f g h i j k l m n o p q r s

UNIFORM

uniforme, einheitlich, uniforme, uniforme, 同型の

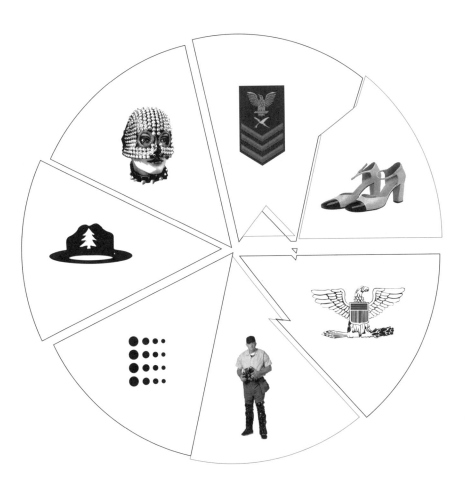

Uu

UNIQUE

único, einzig, unique, unico, ユニークな

UNLUCKY

sin suerte, unglückselig, malchanceux, sfortunato, 不運な

URBAN

urbano, städtisch, urbain, urbano, 都会の

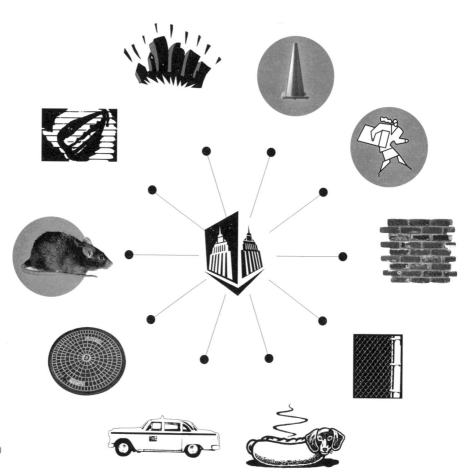

URGENT

urgente, dringend, urgent, urgente, 至急の

VACATION

vacaciones, Urlaub, vacances, vacanza, 休暇

v w x y z

a b c d e f g h i j k l m n o p q r s t u

VINTAGE

excelente, glänzend, classique, classico, 銘柄の

VIRTUOUS

virtuoso, tugendhaft, vertueux, virtuoso, 高潔な

VISIONARY

visionario, visionär, visionnaire, visionario, 幻の

WAR

guerra, Krieg, guerre, guerra, 戦争

WEAK

débil, schwach, faible, debole, 弱い

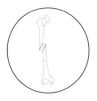
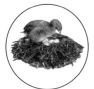

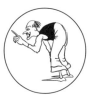
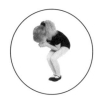

WEATHER

tiempo, Wetter, temps, tempo, 天候

WET

mojado, nass, humide, umido, 湿った

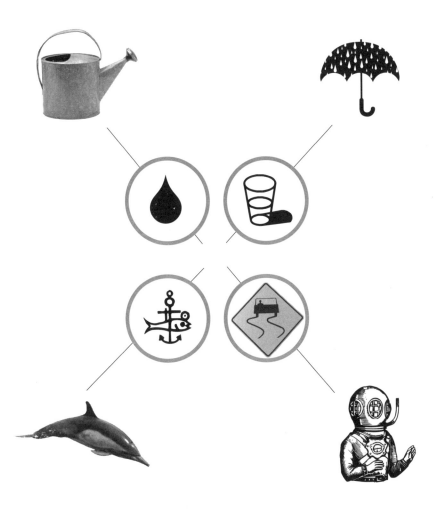

WHIMSICAL

caprichoso, wunderlich, fantaisiste, estroso, 気紛れな

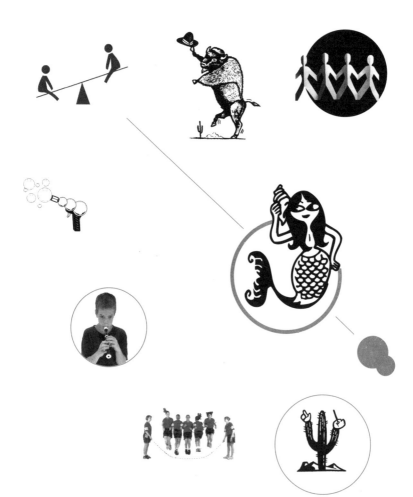

WILD

salvaje, wild, sauvage, selvaggio, 野生的な

YEARN

añorar, sich sehnen, languir, struggersi, あこがれる

YOUNG

joven, jung, jeune, giovane, 若い

DIRECTORIES

English

English

Spanish

a tierra	72	caro	83	encendido	108
abotagarse	29	cauteloso	33	enérgico	77
absurdo	12	celebrar	34	enfermedad	134
académico	13	celestial	35,123	enfocado	95
acogedor	51	celoso	143	enorme	132
adorable	154	científico	241	entretener	78
aerodinámico	267	clásico	37	erótico	80
aeronáutico	14	cóctel	39	español	263
afortunado	155	cojo	146	espía	264
afrutado	100	cómodo	41	estúpido	270
agotado	82	compañero	205	excelente	289
agradecido	274	compartiendo	245	extraño	220
agresivo	16	complejo	43	extravagante	201
ahorrativo	275	comunicación	42	fácil	73
ajeno	178	confiable	228	fantasia	85
alegrarse mucho	225	construcción	46	feliz	120
alemán	107	contagioso	47	femenino	88
alivio	229	contemporáneo	48	feo	282
amargo	28	corporativo	49	financiero	89
ambiental	79	creciente	114	firme	90
americano	17	credible	52	flaco	250
amigable	99	cuento de hadas	84	flexible	94
analítico	18	culinario	53	frágil	96
animado	31	de actitud abierta	193	francés	97
animal	22	de alta tecnología	125	fresco	98
añorar	298	de terror	239	frío	40
anticuado	192	débil	293	fuerte	268
antiguo	19	decidido	59	futurista	103
arqueología	23	delicioso	58	geografía	105
artesanal	118	desesperado	129	geométrico	106
artístico	24	deshonesto	63	gobierno	109
Asiático	25	desviado	60	gordo	87
áspero	233	día feriado	126	gracioso	102
atlético	26	digno	61	grande	148
avaricioso	112	diligente	137	gruñón	113
azorado	76	directo	203	guapo	119
bandido	202	disperso	240	guerra	292
barato	36	divertido	101	hábil	249, 253
bello	27	doloroso	204	honorable	128
blando	261	dominante	64	honrado	127
borracho	67	dramático	65	hospitalario	130
brillante	30	egipcio	74	humano	133
caliente	131	electrizante	75	importante	136
callado	221	elegante	110, 271	inmediato	135
capaz	32	elogios	214	inteligente	256
caprichoso	296	emocionante	81	italiano	139

Spanish

japonés	142	oloroso	185	sencillo	247
joven	299	oportuno	276	sensual	243
juego	104	opresivo	195	sexual	244
juguetón	209	optimista	196	sin suerte	285
justicia	144	opuesto	194	social	260
juvenil	145	opulento	197	sofisticado	262
largo	153	orgánico	198	solo	248
latino	149	organizado	199	somnoliento	252
lento	254	orgulloso	219	sucio	62
ligero	151	orientación	115	sustancioso	122
limpio	38	ortodoxo	200	temeroso	15
liso	257	oscuro	179	terco	269
loco	138	oscuro	55	tiempo	294
lógico	152	pacífico	206	tierno	273
lustrose	251	pegajoso	265	tieso	266
maduro	159	peligroso	54	tonto	246
mágico	157	pequeño	255	trabajo en equipo	272
magnífico	111	perfecto	207	trágico	277
maquinaria	156	perspectiva	208	tropical	279
maravilloso	66	pobre	212	único	284
masculine	158	poco convencional	188	uniforme	283
matrimonio	160	poderoso	213	urbano	286
medico	164	prehistórico	215	urgente	287
medios	161	primero	91	útil	124
mexicano	165	professional	216	vacaciones	288
military	166	promocional	217	vago	150
misterioso	169	protector	218	valiente	50
moderno	167	rápido	86	viajes	278
mojado	295	raro	184	viejo	191
monumento	147	real	234	virtuoso	290
mortal	57	recreativo	222	visionario	291
muerto	56	reflectante	223		
musical	168	refrescante	224		
natural	170	rejuvenecedor	226		
naútico	171	relajante	227		
nervioso	173	reservado	242		
no sofisticado	172	retro	230		
Nuevo	174	rico	231		
obediente	177	romántico	232		
observador	180	room	71		
obsoleto	176	Ruidoso	175		
oceánico	183	rural	235		
oculto	181	salvaje	297		
ocupación	182	sano	121		
ofensivo	189	seco	70		
official	190	seguro	238		

German

German

French

French

Italian

Italian

Japanese

Japanese